Rosemarie Beck

Letters to a Young Painter and Other Writings

Edited by Eric Sutphin

Soberscove Press | Chicago

Soberscove Press
Chicago, Illinois
www.soberscove.com

Library of Congress Control Number: 2017958306
Beck, Rosemarie, 1923–2003
Rosemarie Beck: letters to a young painter and other writings / edited by
Eric Sutphin

ISBN 978-1-940190-19-8
Second Printing 2018

Design by Rita Lascaro
Printed in the United States

Contents

Introduction
Eric Sutphin

*". . . as narrative painters we want some of the same
privileges accorded writers. We want to be as
witness-bearing or specific as any letter-writer."* [1]

The work of Rosemarie Beck (1923–2003), best known as a narrative painter, remains difficult to classify. Though she began her career as a second-generation Abstract Expressionist, her work has been associated with groups and movements as varied as abstract impressionism and painterly figuration. In the late 1960s, Beck became a central figure in a loosely aligned group of painters, which included Leland Bell, Neil Welliver, Paul

1 Rosemarie Beck, "The Meaning of Persona in Narrative Painting" (1980), p. 77.

Georges, and Paul Resika. The group organized themselves around the Alliance of Figurative Artists, which began in 1969 and held weekly meetings at the Educational Alliance on East Broadway in New York's Lower East Side. The Alliance, which lasted until the early 1980s, became a hub of an often-heated exchange centered on issues concerning contemporary figurative painting; it formed, in fact, because the work of the painters in the Alliance was virtually ignored by critics, whose attention was fixed on Pop, Minimalism, and Conceptual Art. To many critics, the return to figuration was seen as regressive or revivalist, and though a handful were sympathetic to this new generation of representational painters, their work generally lacked a cohesive body of criticism. If critics did discuss their paintings, it was often framed in opposition to the ascendant avant-garde movements; abstraction pitted against figuration served as a way to enliven copy, ruffle feathers, and sell magazines.

Artists, including Beck, wrote criticism as a way to engage directly with the work, to discuss its formal and conceptual motivations, and to foreground what the work was, rather than what it opposed. Beck's own critical writing arose out of utility, and she used it to situate herself, and her work, within a shifting and expanding art world.[2] Though she never identified herself as a critic per se, Beck's writing can nevertheless be understood in the context of other painter-writers from this moment, such as Fairfield Porter, Sidney Tillam, Louis Finkelstein, and Rackstraw Downes—all of whom oriented their criticism toward a more nuanced and complete account of contemporary figuration. In 1974, Rackstraw Downes published, "What the Sixties Meant to Me," an eloquent article

2 "Why artists should try criticism: responsibility for establishing values." Rosemarie Beck, *Journal #1* (March 1, 1954), p. 19.

in which he accounts for this milieu, citing the work of these figurative painters as "the unofficial art of the 1960s."[3] In his essay, Downes discusses the ways in which these artists utilized history—both recent and distant—as a vehicle through which they could revisit narrative in a fresh way: "[They] needed the past to help expand the means that abstract art had bequeathed them."[4]

Beck's own writings offer new perspective and augment the scant criticism available around this significant (yet under-documented) moment in postwar-American painting. In reading her various statements, lectures, and letters, it became clear that a volume of Beck's writings would be timely and that her canny prose would complement the renewed discourse surrounding the achievements of under-recognized painters, in particular women, of the New York School. Beck's legacy is foremost as a painter, so it is imperative that a volume of her writings be framed in relation to the causes and conditions (in the studio and beyond) that formed her mature work.

Beck began to paint in earnest around 1946 and emerged as a second-generation Abstract Expressionist under the guidance of her first mentors—Philip Guston and Bradley Walker Tomlin—who were her neighbors in Woodstock, New York, where she lived with her husband, the literary critic and writer, Robert Phelps (1922–1989). Beck worked for a time out of Robert Motherwell's studio and attended the "Subjects of the Artists" lectures there—she was steeped in intellectual ferment,

3 Rackstraw Downes, "What the Sixties Meant to Me," *Nature and Art Are Physical* (New York: Edgewise Press, 2014), p. 63. Downes's essay was originally delivered as a lecture at Cedar Rapids Art Center, Iowa on November 23, 1973. The essay was first published in *Art Journal* XXXIV (Winter 1974–75).

4 Ibid., p. 65.

debating Kierkegaard, reading Rilke and Auden. Her first solo show was at Peridot Gallery in 1953, and she was included in a number of important exhibitions throughout the 1950s.[5] In 1954, despite increasing critical attention and commercial success, Beck entered a period of crisis in her work, and began to feel that by working in a purely abstract mode, she was always "at the mercy of the *look*" of a painting.[6] She later confessed to being a "closet" realist.[7] W. H. Auden's maxim, "[a]rt is not enough," fortified her resolve to begin to incorporate "external referents" (still life objects, portraits) into her work.[8]

By the late 1950s, the esprit de corps that once characterized the New York School had dissolved, and artists, critics, and institutions were anxiously poised to see what the next new movement might be. Critical attention was now fixed on post-painterly abstraction and Color Field painting, which were being championed by Clement Greenberg. By 1958, in the midst of this shift, Beck had moved completely away from non-objective painting and began to paint representational tableaux. She had strayed from modernist ideals (so-called "pure painting") and was folding into her work extra-painterly concerns: the contingencies of human expression, the rhythm of

5 Founded in 1948 by Louis Pollock, Peridot was an important gallery in the 10th Street District. Beck had her first solo exhibition at Peridot in 1953, and was represented there until 1972.

6 Rosemarie Beck, *Journal #4* (November 16, 1958), p. 28. Beck wrote: "One reason I've gone to the object is that I find it superficial always to be at the mercy of the look of the surface. The look is incidental to total making. And anyway who isn't on the lookout for the snares of the myriad conventions of contemporary painting?"

7 "Lecture Delivered at Queens College," p. 71.

8 Rosemarie Beck, "Text of an Informal Talk," (Lecture, Wesleyan University, Middletown, Connecticut, May 1960), p. 3.

bodies in space, and her immediate surroundings. Beck titled her first representational series *House of Venus*—paintings that included large, invented still lifes that seemed to emerge from loose, pale golden grids. She described the moment when she brought these to Peridot: "When I first showed them to my dealer he was very abashed."[9] Nevertheless, Beck maintained a formalist position (an insistence on the picture plane and abstract rhythms) throughout her career, despite her incorporation of recognizable subject matter. She simply didn't adhere to Greenberg's dictum that a painting's formal integrity was eroded by realism, an idea she made especially vivid in her writings about Rembrandt.[10] In essence, her ethos was founded on the idea that a painting, regardless of its degree of figurative reference, was always abstract, and she bristled at the tendency in criticism to pit the abstract against the figurative. For Beck, artistic progress was not limited to an offshoot of modernist critique, but, she believed, could likewise be achieved through an erstwhile reinvestment with history and tradition.

As a fervent journal-keeper and bibliophile, an intimate relation between her own writing, literature, and painting was established early in her career. Beck left behind volumes of letters, journals, lectures, and essays on art—these include analyses of her own work, the work of her peers, work from the canon, and, finally, the *Letters to a Young Painter*, an epistolary lecture project that consists of sixteen rhetorical letters addressed to a fictional young artist. She approached her texts in the same manner as she would have approached a complex narrative painting: through a combination of literary sources,

9 As told to Kim Levin in an October 1978 audio recording.

10 "Reflections on Works from the Metropolitan Museum of Art," p. 84–86.

metaphor, re-readings of historical painting, and observation. With a lucid and authoritative voice, Beck addresses the rift between the said and the seen, or, as she described to "B.," "the gulf between symbol and fact."[11]

In 1960, Beck gave a lecture to students at Wesleyan University on the occasion of her first retrospective, which had opened there in January of that same year. She titled the lecture, "In My Studio," and framed it as ten questions she might ask herself as she entered the studio to work; her statements are delivered as replies to her own ruminations.[12] Beck used the occasion to, in effect, renounce her alignment with Abstract Expressionism and she would come to refer to it as her "apostasy." A version of this lecture was published in 1961 for *Arts Yearbook* 5, edited by Hilton Kramer. In some ways, Beck was reacting against the existential interiority that came to characterize much of the discourse around Abstract Expressionism— she had shifted her gaze to the objects, people, and surfaces that comprised her lived and felt domain. When once asked about her turn to representation, she simply stated, "*Things* are so fraught with meaning."[13]

Beck began to employ allegory in her work in the early 1960s, and archetypal themes and figures served as pretexts for her to paint more directly about her own experience. She began to paint large, multi-figure compositions comprised of women—models, her self, friends, and cited figures from

11 "Letter to B.," p. 47.

12 In January 1959, in preparation for the Wesleyan lecture, Beck created a rhetorical questionnaire to herself. In it, Beck posed herself a series of questions and answers as to her conceptual motivations for turning to representation in her work after 1958. Rosemarie Beck, *Journal #4* (January 1959). See p. 61.

13 As told to Kim Levin in an October 1978 audio recording.

historical paintings—who were staged in fictionalized spaces that register simultaneously as studio and theatre. From 1960 until roughly 1965, Beck painted thematic tableaux that explicitly dealt with the twinned role of woman and artist. In "The Annunciation" (1960–62), a young ballet dancer is called upon; in "Le Maquillage" (1961–63), women ready themselves at their vanity for an unknown event; in "The Magdalen" (1963–65), the awakened woman gazes out at the viewer, alone but liberated. To Levin, Beck explained that these series were "thematic rather than narrative," and the central question, "How difficult *is* the vocation of being a beautiful woman *and* an artist?"[14] The impetus for these series came, in addition to her own experience, from close readings of the French proto-feminist writer Colette as well as Virginia Woolf's diaries. As historian and critic Jennifer Samet has noted:

> There is something delightfully subversive about seeing the traditional view of an artist's studio so thoroughly occupied by women in a multiplicity of guises. Beck lived her life as a profound intellect amidst a bevy of brilliant men. In her "Maquillage"/"Magdalen" series, she envisioned her studio as a refuge of the feminine.[15]

Beck reached artistic maturity in a pre-feminist moment and her subject matter certainly suggests that womanhood is a motif. Nevertheless, there is only one instance in her journals where Beck mentions the term "feminist." It occurs in an

14 As told to Kim Levin in an October 1978 audio recording.

15 Jennifer Samet, "Space of Desire: The Paintings of Rosemarie Beck," catalogue essay for *Rosemarie Beck: Le Maquillage/Magdalen* at Steven Harvey Fine Art Projects, New York, NY (May 30–June 30, 2013).

entry from 1954, as she considered Rosa Bonheur's work at the Metropolitan Museum. Beck doubted that Bonheur "could ever make a man painter envious."[16] Later, probably around 1978, Beck noted in the margin of that entry, "Am I suddenly a feminist?" The addendum was written as Beck was preparing for her *Arts* interview and suggests that by the late 1970s, Beck had reevaluated her previous stance on femininity-as-subject, and that she had become more comfortable with feminist readings of her work.

• • •

In the 1970s, Beck began to paint directly from literary sources. Prior to this, her narrative subjects were "analogic"—narrative content (women putting on their faces, for example) was implied but not fully embraced. Among her sources from this period were *The Tempest*, Ovid's *Metamorphosis,* and the Orpheus myth. During this decade, Beck began to go on record about her career trajectory, her sources, and the ways in which autobiography figured in her work. Beck's words appeared in print in an interview in *Arts,* "A Conversation With Rosemarie Beck," and in Lorraine Gilligan's essay, "Rosemarie Beck," in *20 Figure Painters and How They Work.*[17] The latter volume was published as a compendium by *American Artist* magazine and included essays about Alice Neel, Philip Pearlstein, and Barkley Hendricks, amongst other widely recognized figurative painters.

The first section of this volume presents Beck's *Letters to a Young Painter,* which are published here in their entirety

16 Rosemarie Beck, *Journal #1* (March 12, 1954), p. 21.

17 Kim Levin, "A Conversation with Rosemarie Beck," *Arts* 53.6 (1979), p. 105–107. See also: Lorraine Gilligan, "Rosemarie Beck," in Susan E. Meyer (ed,), *20 Figure Painters and How They Work* (New York: Watson-Guptill Publications, 1979), p. 10–17.

for the first time. For the *Letters*, Beck revisited the rhetorical style she had used in her Wesleyan address and adapted it to an epistolary format in the manner of Rilke's *Letters to a Young Poet*. The letters were initially conceived for a lecture Beck was scheduled to present in the autumn of 1967 at the University of Delaware; however, she ultimately abandoned the project.[18] As she was first developing the idea, she included a brief and revealing statement about her conceptual motivations in her application for a Guggenheim Fellowship in January 1966.

> I have a project in mind which has variously occupied my thoughts in the last year or so, provoked by my teaching and certain questions I keep asking myself. It reduces simply to this: how does a young woman who aspires to paint prepare herself for the vocation of artist today? I am thinking of casting this paper in the form of letters from a not-so-young woman painter to a composite-imaginary young woman setting forth on her dangerous voyage in search of the self out of which her 'thing' is to be invented and perfected.

After nearly three decades, Beck returned to the premise in the mid-1990s and presented the *Letters* at various colleges and universities, such as, the New York Studio School, Vassar, Swarthmore, and Wright State University. In the letters, Beck moves between explication, autobiography, and ekphrasis, and their tone suggests that they are a kind of epilogue to her career. In some instances, Beck's message is clear and direct: "I assert stentoriously in the face of a rich still life of fruits and flowers

18 John McIntyre, "Rosemarie Beck: Letters to a Young Painter," *American Arts Quarterly* 33.2 (Spring 2015).

and a lovely model, 'Don't record the objects; verisimilitude is not truth, at least, not truth to the subjects of painting'—it's the grammar we're after!" At other times, the message is delivered as analogy, its contents unfolding slowly. In one passage she describes an abundant lunch spread at Yaddo: the well-appointed table was a metaphor for good form and the pleasures of art making. What Beck is doing in her letters is precisely what she sought in her visual art: to embody sensuous and affective experience within concrete forms, to marry aesthetic pleasure with formal and conceptual complexity.

Additionally, three texts gathered here—"Lecture Delivered at Queens College" (1975), "On the Orpheus Theme" (1975), and "The Meaning of Persona in Narrative Painting" (1980)— deal directly with the relationship between her subject matter and the events, private and professional, which lead her to these various themes. The final section includes a series of reflections on works from the Metropolitan Museum of Art. Here, Beck discusses a selection of works that were formative throughout her career, which she articulates with a kind of buoyant earnestness. Through my various interviews and conversations with Beck's colleagues and students, a singular theme emerges: her extraordinary breadth of knowledge, which was broadcast in stream-of-consciousness soliloquies. Beck spoke continually for the duration of classes, letting her thoughts pour forth as she gesticulated wildly while students worked. Beck's essays give one a sense of her aesthetic hypotheses, which she tested throughout her own painting and teaching.

Beck once wryly proclaimed herself to be the "last anachroniste."[19] She frequently called into question the fetish for "the

19 As told to Kim Levin in an October 1978 audio recording.

new" and understood that being a painter meant accepting a certain amount of risk. She courted risk by choosing subjects that were considered anodyne: as some artists were looking to comic strips, Beck was looking back to Bonnard and Rembrandt. Throughout her lifework, Beck posits that one solution is no less valid than any other, and that distinctions between "major" versus "minor" or abstract versus figurative, are insufficient metrics. When speaking about going back to narrative painting, Beck noted, "Fundamentally I believe it is simply temperament. Ambition may be one of the components—to paint like the masters, to track the unknown, and to relish, in some trepidation, being off-center, a little vulgar, anachronistic."[20] Beck points to the psychological, social, and formal predicaments that pervade the creative act. At each impasse, she demonstrates that the solution is inevitably located through or within the work. Beck's anecdotes and propositions—whether delivered as lecture or letter—coalesce into a generative (generous!) amalgamation out of which one's own "inner imperatives" are encouraged to germinate and proliferate. While Beck held a firm position about what she valued in art, she implores her reader to decide for herself what is important, to discover a form that can best transmit that idea, and to pursue it with temerity, clarity, and truth.

20 "The Meaning of Persona in Narrative Painting," p. 78.

Editor's Note (E.N.) *In her writings, Rosemarie Beck's punctuation and spelling often reflected her breathlessly frenetic speech. I have, for the most part, retained Beck's occasionally idiosyncratic spellings and capitalizations, but I have normalized for consistency some conventions, including the use of "(sic)" to indicate the misspelling of a proper name ("Epicurious" for "Epicurus," for instance). In addition, I have very occasionally corrected obvious misspellings in English in the interest of intelligibility, but have retained misspellings when they were clearly the result of a frantic expository mind put to the page. I have tried to keep explanatory notes to a minimum, but have included them on the occasion when I feel textual references would be enhanced by their inclusion.*

I.
Letters to a Young Painter
(1966–1999)

E.N.: *Beck presented these letters on November 23, 1999, as* A Series of Letters *at the New York Studio School. The order in which they are organized here is taken from the sequence in which she read them for this talk. Though Beck began the letters in 1966, she abandoned the premise for nearly three decades and returned to the project in the mid-1990s.[21] In his 2015 article in* American Arts Quarterly, *John McIntyre gives a brief account of the history of the* Letters *project. Here, McIntyre notes that Beck was preparing to deliver the* Letters *as a lecture at University of Delaware in 1967, but that she abandoned the project because, "My initial enthusiasm for the project had passed. I didn't want to instruct or bear witness for the moment." The letters underwent many cycles of revision and modification. Each letter begins addressed to a set of initials, which suggests that they had their genesis in an actual piece of correspondence. However, Beck was emphatic about their rhetorical nature. Despite the temptation to postulate for whom the letter was initially intended, they are meant to be experienced as pedagogical and rhetorical, rather than biographical.*

21 John McIntyre, "Rosemarie Beck: Letters to a Young Painter," *American Arts Quarterly* 33.2 (Spring 2015).

Dear P.,

I wish I knew precisely what you mean when you say you are forced to sacrifice so much to be an artist? Surely it isn't nice clothes, dinner parties, a place in society, kindness to others, good works in the world? This Romantic idea has been served up to us for at least 100 years confounding the maker with his product. Isn't it the other way around? Doesn't art get sacrificed to life matters—all so importunate, so clamorous—who paints when a baby cries? Who rushes to the Bonnard book when the oil man is coming with the bill? The real source of discrepancy is not the exigencies of life which being human we can't escape, but the way we are regarded in this materialistic world. It's the almighty dollar and the bitch-goddess success that call the tune every time. So with the exception of the very

few who have exemplary market value, hence, *hors du concours*, most of us are interruptible and bothered by just about anything. I have learned to say, when I'm going to paint, that I'm really doing something else like giving a lesson or seeing the tax man or sleeping—all more excusable activities than daubing to no ostensible purpose. It's maddening that one has to be clear and assumptive and self-important without a shred of concrete proof in the value of our activity . . . maddening!

The first generation of abstract expressionists were mostly poor and hard-pressed quite long into their careers, and suspicious of recognition—"you've sold out!" [was] a not uncommon criticism when one of them appeared in a Burberry coat at the Cedar Tavern. Sooner or later, most were infected by the American dream of Success. *Risk*, the banner under which they performed their covert work in the studio, veered haplessly into the real world of *Making It*, making it with galleries, critics, magazines, the public. A new equation emerged: you are not a success as an artist if you refuse the risk of the real world. Having lawyers, accountants, speaking out in public, living dangerously, changing wives, was equal to the battle in the studio, invaded the studio, adding inflammatory hurry, exaggerated scale, publicized the internal monologue, eventually eroding its efficacy . . . is it any wonder most were alcoholics?

Am I begging the question implied in the second part of your letter where, in effect, you accuse us, your former teachers, of a failure to prepare you for your career, of never talking about the state of the art world, in short, how to make it out there? We offered you an ivory tower, you say. At best, if we mentioned the condition at all, it was an irreconcilable state not to interfere with how to become an artist. To this all I can say is Tough!

Dear R.V.,

I certainly owe you an explanation for not talking to you at your opening. Though openings are not the place for heavy intellectual exchange these days. In the fifties and sixties they were not the polite occasions for chitchat and hugs they have since become.

I have no quibble with your work on formal grounds, and in certain quarters that should be enough. But I do have reservations about your classical and other titles and what I am required to get [out] of them. I wonder, you see, if it is frivolous to label a patently abstract expressionist painting with the kind of specification evident from your titles: *Jonathan's Swimming Hole in Winter When it is Cold*; *Orpheus Destroyed by the Furies*; or *Exile, Loneliness, Our Fate?*

We have been given absolute autonomy as artists in all our endeavors, license and liberty as to the sources of our feelings out of which our work is fabricated. And only a fool would state that the sources of feeling exist only in the formal or plastic or perceptual or conceptual. We are just as likely to be roused or motivated by life, emotion, jealousy, memory and parallels in literature, music, philosophy, religious faith, or a person, condition.

I do not believe you make this external specific visible in your work by simply naming it. At least it is not enough for me. If we are going to call ourselves narrative painters, I think we must engage in very specific particulars "out there" otherwise the metaphor is incomplete, or rather, no metaphor.
Yes, let's talk!

Dear C.E.,

You ask me why I use narrative themes in my painting? Here are some thoughts on the subject.

When you compare the hyperbolic visual enterprises practiced in our electronic computer age with the hapless little rectangle which is the province of the painter, it's enough to make one GASP. But painters are not merely visual machines. They are galvanized, in fact, by the very limitation of their format.

This format of *just so many inches* is the place of his formal predications and predicaments; and if he is of a certain kind of temperament—ambitious, Faustian, hungry—then he may need to include, or, rather, implicate an extra-painterly component into his predicament: the narrative, for instance. It's just another way of his saying within the confines of his picture that "Art is not enough." However, desiring to say something very specific about his human condition or *the* human condition, he places himself at serious risk. . . . I mean, how does he account for Mondrian? He must accept a formal compromise. Apropos, I remember Philip Guston saying after a long study of a Mondrian painting: "I want to prove him wrong!" After all, abstract art is the noble invention of our time, productive and liberating? Which proclaims: Art can never be translated into anything but itself. "Pride hath no glass to show itself than pride."

In defense of the use of it, I can only say for myself that it disarms ease and forces the formal imagination as it sets up stumbling blocks, as it creates insolubles. It stimulates the appetite for composition in the degree that it increases the desire to concretize emotion. It makes it more difficult to get

into the kingdom ... but Valery said something like this so eloquently:

"I am thinking of quite other difficulties, problems of a higher order, incomprehensible to most people (and even to some who practice the craft), which the true artist invents for himself. He invents—as one might a form, an idea, an experience—hidden conditions and restrictions, invisible obstacles which accentuate his design, impede his acquired facility, delay his satisfaction, so as to draw from him what he did not know he possessed. I hold [that] this invisible inner work of inventing desire and scruples is perhaps more profoundly important than the visible one to which his efforts tend: and that this secret struggle with the self shapes and alters him who practices it even more than his hands modify their chosen material."

Essentially there are two kinds of narrative with some overlap and mutual interpretation. On the one hand, myth, stories, legends, iconography available to all or known to all as biblical stories, for instance, which comprise the material of the painters in the past with dashes of personal interpretation as well as the imperative to bring the material up to date. Hence, it's never Jerusalem in the first century B.C. but 15th Century Florence or 17th Century Holland. Rembrandt is the ideal prototype. But all great painters have a characteristic in common: that we are moved by the narrative embedded in the right form before we know what it is.

Most contemporary painters who use narrative belong to a second category wherein the iconography is personal, invented,

secret—subscribing often to non-translatable obsessions or fantasies or allegories. The late Philip Guston and Leland Bell come to mind. Picasso, De Chirico, Balthus, Chagall and Gorky all invented forms or images to express their often esoteric narrative urgencies.

There's yet a third category to which I personally cannot bring my allegiance which I'll call Fantasy with a flat F. It may be fertile and it is often productive and many good painters' work herein. In brief, it's where anything can be anywhere and the schema or Ars Poetica is very indulgent. . . . But enough.

Dear W.K.,

Yes, I am disappointed, and . . . irritated. I believe you were making progress: your color, it seemed to me, was beginning to serve the purpose of drawing and vice versa.

And now, having barely gotten your feet wet, you want to turn away from all formal considerations to explore your inner subject matter. You want to be disburdened—your word—so as to be able to get at the true sources of feeling and inspiration. You want to "feel." You want to fix the person and improve the life and become part of the great Unck, or whatever it is.

Unless the clouds are talking to you or you are flat on your back in a dungeon of despair, all of this exclaiming is piffle to me. Everyone I ever know who gave up Art to fix the person so as to create the right kind of art, was lost to art. I am not, of course, talking about therapy or medicine when necessary. You see, I'm convinced that art makes the person, if you're meant to be an artist, not the other way around.

I remember a certain Herman P. when I first went to Yaddo. H.P. was a sculptor who arrived in paradise with barrels of plaster and wire and boxes of impressive tools. Long before anyone ever heard of cholesterol or salt intake, H. was obsessed with food. Now, one of the bonuses of Yaddo was a prideful table: roasted meats, spinach soufflés with mushroom sauce tenderized with cream. Pies, cakes, cheese and roast beef sandwiches in the lunch pails. "You are all being poisoned," said H. who made little messes out of dried fish eyes and bitter greens and odd little black beans hard as stones. He came to meals only to bleat and fish out a few peas and carrots from the stew. He was obsessed, totally, and could think of, or talk about, nothing except his stomach. He may

well have improved the body but he did no work while the sacks of plaster and wire lay permanently unopened under the skylight beam.

I have never heard his name since. I imagine he is an inspired gardener somewhere, or perhaps he lies in an early grave poisoned by a crab claw?

Dear E.,

C.C. and I sat next to each other at the dinner honoring W.N. last night. After the toasts, small talk, niceties, and a discussion of the pasta which offered in its sauce so many conflicting substances and flavors as to prove, finally, tasteless, the young man opposite us began to talk about Art. What did we think most counted for the Painter? What is his role? Clearly he had cut his teeth on Clement Greenberg. He believed in the heroic adventure of modern art, referring to everything else as 19th century. What counted for him was the inexorable teleological inevitability of progress . . . groans from us, naturally. We'd heard it all before—45 years ago, and the talk then, in the light of this questionable logic, was almost always, who was major or minor. If you subscribed to 'progress' or innovation or whatever you want to call it, you were major no matter what your majority consisted of. Casting your bedclothes on the canvas, burning holes, or any variation of the drip theme, meant major. Practically anything else was minor.

C. and I concurred in a bitter cackle that finally the only thing left in the rubble was/is the presence of a voice. My late husband referred to this quality as the scent on the lamppost. Any discussion of major or minor we agreed, was futile and untenable.

So it has finally come to this: it's the Voice that counts, even above good picture making, or superior consciousness, or the felicities of performance. This voice over which we have only little glimpses, loses its efficacy when we chase after it, and its persuasiveness diminishes in proportion as we become self-imitators.

To be an artist seems to require great trust, a kind of naïveté, and the most difficult of all tasks—especially in the

face of so much to learn, so much to attempt—sincerity to one's inner rhythms and exhortations, and appetites, loves, needs, and perhaps, above all, the need to confess or tell the secret however disguised.

Dear W.,

Of course I agree with you when, in your comparison of painters A and B, you emphatically state that A is the morally superior, though you concede to B's technical wizardry. But this sets my mind to wander into the realms of meaning and value. In what way is A more valuable than B, and how is the meaning more proliferating or more important?

I'm not equipped for philosophical argument. All I can offer is an example that haunts me.

A quality entered the world of paintings' possibilities in the late 19th century—glimpsed in the past, though not necessarily avowed—specifically encountered in the late works of Cezanne and Degas, and later in Giacometti, a quality I will call doubt or dissatisfaction, with the attendant need to correct and to correct again, a quality which was integrated into the painting process itself as an instrument of its very making, of its truest expression. In genuine and original painters this quality wears the mantle of style and enters history as yet another possibility for extension, for biography (as in the very time of its making), for richness and ambiguity. I call this an act of morality. It represents the inevitable predicament of a lifework of the severest aspiration and self-questioning. Finally, it is the avowal of the artist's aesthetics, the morality of his aesthetics—*going all the way*. When this quality is unearned by a succeeding generation, adopted as a style with attendant breast-beating, it's patently immoral to me. Doubt has to be earned else it's puff or mannerism.

On a somewhat lighter plane of talk about morality, I have heard artists praised for their dedication to the particular, for this accumulation of minutely observed details from life as an

alternative to the less-than-trustworthy secretion of not-quite-to-be-trusted self-conscious formal events. "Get on with it," you can hear them say. "Be simple and direct!"

With rare exceptions, painters in their youthful productive periods paint for their careers, for their position, and to play out their talents and accomplishments while claiming their territory and The New. When all of this passes, and it does, when the clamor passes—the inner imperatives, finally, are all that remain. The showy gifts of youth, the capacity for richness and adumbration, seem to fall away. But of course it is a mistaken notion to believe that this art is simple or stripped or reduced. Rather, it's a complex of unexpected ways, in the same way that parts serve the whole within the internal schema. Finally, the statement is supremely personal: it dares to be; or, rather, it knows no other way.

Dear L.,

Thank you for the feast. Most of the painters I know are wonderful cooks, especially the men. Undeterred by recipe books or cholesterol anxiety they permit a certain existential flair and surprise. Our gormandizing established exactly the right frame of mind for discussing the non-serious and fertilizing aspects of the art we too sedulously practice most of the time; how to be light, playful, humorous, fanciful; how to get at the parts of ourselves that lie dormant and unattended in the psyche. "Epicurious (sic), himself, found Jupiter's brain in a piece of Cytheridian cheese."

One provocation might well be having an external occasion . . . say you had to decorate a room for a Christmas party, or an informal wedding, and all you had in the way of material was a roll of brown wrapping paper and a few jars of water paint, and of course, that very specific *deadline* which doesn't permit the luxury of reflection, hence, bat-wing doubt. Doesn't the imagination begin to flare its nostrils? You can borrow shamelessly from anywhere, try strategies you never had time for, use your accumulated book of forms for totally different ends—in short, do anything at all, including the prohibited. What if you had to do a theatre set (not of course, the commercial, expensive kind of production) in collaboration, as de Kooning did, or the artists who worked for Diaghilev? What if a friend asked you to illustrate his poems or musical composition? To let fall once in a while the critical stance liberates the imagination as it taps the goofiness, the unexpected, perhaps the scatological, and the sometimes thwarted improvisational gifts in the person.

Did I ever tell you a dear all-too homely Guston story from our years in Woodstock? He was heard to moan frequently

about the unending stream of ceremonies in the life of a child. "God, now it's Easter bunny time, and didn't we just get over Valentine's and birthday and Christmas?!" But, in fact, grudgingly at first, I think he welcomed these occasions because they always elicited from him enchanting, non-serious decorations. One day he presented his little daughter to us early Halloween morning before he was to drive her to the school party. The evening before had been riotously spent inventing a witch's costume consisting of a marvelously illuminated sheet with figures and imagery, a fabulous hat and a carved jack-o-lantern carved in the shape of a cat. I've never forgotten the sensuality, the rightness, of that carving. Well, Philip spent a restless day waiting for Ingie[22] to come home from school. She was . . . a little crestfallen. The boy whose mother had bought a skeleton costume from the five and dime won the prize. No matter. Philip was rehearsing, probably unbeknownst to himself, his future imagery and iconography later to surface in the rich forms we know in his last work.

22 The nickname given to Musa Mayer, Philip Guston's daughter.

Dear R.D.,

Forgive the long delay. Not deliberate. I had your letter pinned up on my bulletin board and have been re-reading it since its arrival.

I guess I was troubled by your reaction: your dismay over a mere critique, surprised me. But if I think on it a little, in the light of my youth—youth being another way of saying one believes in justice—well then I'm full of sympathy. I'm a symphony of sympathies.

I wish I could convince you of the suffocating unimportance of opinion disguised as objective truth, especially as they are qualified by the critic's need to make a name, perform well, or otherwise push for his cause, his own raison d'etre. Alas, artists get crickets (*sic*) the way ships barnacles and dogs fleas. I agree it tends to hurt a good deal more when the alleged critic is also a practicing artist and your teacher.

The cricket industry has mushroomed to lunacy—horrors, it's one of the ways artists make a living. Besides, each cricketing date deposits yet another notch on that other extraneous horror, the curriculum vitae. All this has literally nothing to do with the inner life of the artist, with his tempo and education. . . .

If I understand what happened, your two over-life-size figures over which you struggled valiantly for a year were ignored for discussion of several wire-mesh found objects which you rendered in a day: "Fresh, modern, witty, future-making," was the verdict. Is it condescension to be praised for what is not the best one can do? Or is it a misreading of the person, encouraging him to become a productive bumblebee when in fact he is a wild palomino pony? Or just biased and stupid? Following the

fashionable line that it is more important to note and acclaim the most exiguous sketch of a work-in-progress than the accomplished, whole, complex dramatized masterpiece? Artists have enjoyed and preserved their sketches—buds of unqualified truth—but a true artist understands that he cannot imitate the sketch though he can learn from it, for therein lies mannerism, rhetoric, repetition, emptiness.

I'm sure something of you is revealed in those wire sketches. inevitably, but I'll bet that more of you is present in the ambitious figures. While you were struggling to get them right, merely to get them to stand, to keep them alive . . . all the while accomplishing the myriad technical considerations, triumphing over them in a way, as they loomed, and not bothering to consider whether they looked appropriately modern or individualistic enough, whatever we mean by the sincere and authentic got in the act.

Dear D.,

As you see from the postmark, I'm in Venice. Your letter has followed me here with its good wishes, and ... unanswerable questions—unanswerable because here everything appears in the guise of a perfect time pocket and of course I've succumbed. Nothing appears to have changed. The filter is still water and light and a perpetual gentle movement. Is there anything more beautiful than a view? Here, everything is a view, more beautiful and complete than any mere work of painting inevitably limited, fixed and final as it is. The only art that can approach this condition is, perhaps, architecture, where a flock of pigeons can change the face of stone, literally break its surface with an investment of beauty all the greater for this aleatory agitation.

My dear, don't think for a moment that I'm not sympathetic with your predicament as a young painter. With the array of choices before you, liberties and licenses, it's no wonder you're baffled. It's appropriate to be in revolt against the prevailing establishment trends of one's own time, but now it appears as if there were no challenge to the tradition possible any more; in fact, no anti-establishment position can be said to be even remotely new or inspiring.

The New was the place for me when I put my canoe to sea. The then-establishment avant garde was Abstract Expressionism. The New York School painters were my heroes. I've seen hundreds of movements come and go since. Op, Pop, Minimalism, deconstruction, Postmodern, moveable art, and something called Post-Human, earthworks, art depending on philosophy or literature for it's raison d'etre—you know, and a lot of non-art posing as art. The rectangle for good or ill has always been enough

bafflement for me. I tell myself if it isn't capacious enough well, then, I can't consider myself a painter. This very limitation or confinement is the great challenge to question and invention and reconsideration. But remember that this is me talking to myself and not prescribing for you. The thing is to be properly used. If the canvas is not sufficient for your needful expression than you must go elsewhere. One wonders if Raphael of Tintoretto were living today would they be mere painters, or would they have opted for cinema or musical comedy?

Dear W.,

You have had a deep personal loss. You're blocked, you say, in despair. You have my deepest sympathy. I am not going to proffer the pieties and assurances that it will pass. What can we do with our despair, or happiness for that matter, or worse, depression?

For myself, I wish that I didn't believe that acceding is a species of indulgence. I call it laziness. Let us hope making pictures cures two kinds of despair: despair in the work itself, and despair in matters of life. Ills in the work are revealed in the work. Are the ills of life, our own characters, redeemed by the work? Only if we accede to Yeats's predication: "All the most valuable things are useless." Beautiful form in art requires a serious deformation from whatever we mean by the norm.

In the real world it is appropriate to get qualified help from experts. When painting is in crisis nothing can help but work in the studio. In one, at least, very specific fashion, an artist differs from just about anybody because he is an effective opportunist. If he is lucky, he can use all of his material. He has the privileges of opportunism. Joyfulness or plain human happiness may be the more perilous fates for the maker since it is a state of sufficiency in itself—nothing quite equals the condition, say, of being in love—life will lose its edge if it is qualified by a desire to go into the studio. I've forgotten who said, "the ideal condition for an artist is always to be in love with the unattainable object." Hence, he exists in a state of excitation wedded to despair. Joys, or the impulse to life or gratitude for the feeling of being "lived," impregnate; whereas sorrow, loss, self-consciousness, bring forth.

These remarks, so general and abstract, can do you little specific good. I wish you would ask me about, say, cobalt blue. But this bafflement is our fate. Auden said: "The funniest mortals and the kindest are most aware of the baffle of being."

Dear H.,

I really appreciate your telling me why you felt you had to leave our class. You weren't required to do so; for as I see it, your business is only to learn and to attain your self-education as you begin to discover exactly what that is and what it is not. You are on the tightrope and we offer only the solace of a net. If I slip behind your well-meaning, polite explication, this is how it shakes down:

For three months, you say, you were almost always confused or in a state of chaos, and whatever was proffered only added to this hapless state. "I made no headway," you say, "I just got worse. I felt stupid and untalented and believed you didn't respect me, dreaded coming over to my easel."

Well you are wrong, my dear. I lost no respect for you in your dilemma. In fact, your dilemma, so like my own and countless artists, no doubt, was what interested me. I believe what you call your state of chaos is the result of your arrival upon a kind of plateau prematurely in the rush to accomplish a painting. In order to finish it, to get to the end of it, you grew impatient. This prematurity is too strenuous a condition for you to maintain without a history in your work of some kind of visible success behind you. For one thing, you have not yet learned how far you can go too far. For another, you have not had the kind of experience of the means by which you can recover an earlier stage in the development of your painting again and again if need be, so that your going forward, your reaching for complexity, fullness as you perceive it and desire it, does not buckle down in muddle, or disparity.

The aesthetic presumption or precepts of the class depend upon a fairly slow tempo of understanding and awareness and

practice: to savor these precepts along the way, not get rid of them in the thrust to a final expression, was our objective for you. The expression then might well become a meditation upon these precepts, a means, perhaps, of encouraging your own formal appetites.

I am afraid you will reach the same impasse of muddle with any teacher, unless he sets down for you, imposes, strict rules of procedure. Very likely to submit will help you look less confused to yourself. Though, I imagine, you will sooner or later be burdened with a sense of incompleteness, since it is not in your temperament to submit.

Somewhere, socked into this predicament, is the fallacy that by combining all schools of pedagogy, techniques, styles and tastes, the shape of an artist will emerge as the nestling from an egg, intact, ready to take wing. . . .

I wish this were so, but I really don't think it works this way. Something unnamable in the person, perhaps even untenable, in all this confusion, is the operative yeast. In the apparent welter of contradictions he formulates, becoming aware in momentary flashes of insight, of what he cannot do without, and therefore the right steps and tempo come to him, the very tempo of discovery itself. He learns, above all, the difference between accuracy and finish.

Dear H.,

A postscript to an unasked question which is present in the stricken expression on your face and the faces of others too. I serve up a precept with great conviction, and almost immediately offer a qualification, or worse, a totally opposing precept, enough to make you numb, you could say.

For example, I assert stentoriously in the face of a rich still life of fruits and flowers and a lovely model, "Don't record the objects; verisimilitude is not truth, at least, not truth to the subjects of painting—it's the grammar we're after!" And almost immediately, almost in the same breath—"But what if you really hungered for the object—the lemon is a lemon, after all—and wants to be noticed and recorded, the girl is unique claiming recognition."

This is indeed a confounding situation, a burden upon the student. Let's say, truthfully, my pedagogic psychology is questionable. Still in sincerity to my own convictions, if I fail to express this contradiction, I deprive you of the very meaning of art. You see, I believe that right there in the gap between language and the objects out there, in the dichotomy, in the agitated stream of possibilities and questions, you will one day claim your own territory, hoist your own flag, become curious, brave, productive, speriamo!

Dear B.,

Put so baldly, what a question! My philosophy?

I'm going to hedge by saying you're lucky. The language in which you think or philosophize or communicate, as a writer, is the very one in which you perform your vocation. For us visual types this is not so. Effectively to explain what I do I should have to draw it, mold it, daub it. Even though we speak the common language of English, still what I say seems to me to fall far from the tree.

Let me say first as a sort of apologia that I believe the rational element in the person doesn't always hold the greatest interest. It is by way of the very things he cannot defend or by what he cannot express in a language other than the language of the forms he chooses or is chosen by, does he most persuasively engage us. Is it facetious of me to say: where you can't explain it precisely, where you can't shake it down, is where it is?

I strongly hold to what I tried to tell you at Yaddo—lo, these many years ago; namely: though painting may be about subject (as in apples or crucifixions) or about history (as in a sense of time and place—i.e., as in Post-Modern or Pre-Raphaelite); or, as about oneself (as in biography, confessionals, diary jottings); or very much about how it is made (as in technique or tempo—modern art has been called the perception of structure as theme)—fundamentally it's always involved with the heightened sense of relationships among the components.

The objective, realistic part of my nature is sometimes appalled by my own ambition. But this being the case, I wish I had better training. My authority such as it is comes from taste and desire and not from accumulated knowledge. When

I approach the canvas it always feels like the first time, and sometimes I am adrift. Still, I believe that there is nothing more patently stupid and arrogant and self-conscious than deliberate simplicity. Too much is not enough but not enough is not enough.

I am against the fragment. I am trying for the whole. My real ambition, the little nudge or prick at the back of the mind is that each work reach some total experience, like a cat. I watch my cat. He instructs me. He cannot lie, he cannot disguise his exigency. If he is suspicious he is suspicious from his whiskers to the tip of his tail.

I guess I am a painter by way of light. Not light on a surface or lit objects, but light as a brick or block with which I build, to add and subtract, so to speak.

My albatross is the gulf between symbol and fact, or between the general and the particular, or between the whole and the parts, the formed and the forming, continuity and discontinuity. I believe the real subject of a life-work in painting is the putting together of irreconcilables, an activity more important than the image; or, rather, finally, the image, or whatever remains, is the embodiment of this idea.

Dear C.E.,

How can you believe I would disapprove of or be disappointed by your decision to give up figurative painting for pure color? My interest in you is as an artist, not as a certain kind of artist who belongs to a coterie I deem elite. I am interested in your progress, in the ways you find to dedicate yourself. However, I must warn you that my particular experience or bias may find me less learned or competent to understand or help in the field you have chosen—you wouldn't go to a urologist when a dermatologist is more appropriate to the treating of your skin rash?

In the service of figuration, I tend to think in terms of hierarchies. Hence, the components of a painting—*desegno*, drawing, tone, color, edge, plane, surface—assume differing functions in the explicit subjects one considers. When figuration—that is, some reference to what's out there, as in life or art—is suspended, the notion of hierarchies so important to me has to be ditched. In other words, when color is first in the order, fresh eyes are required, and a different set of rules. The quality of the light, thinness or transparency or opacity, amounts, touches—a more crucial sense of the aesthetic. Clement Greenberg said, "Abstract art affords a deeper, more unequivocal aesthetic experience." To put it very simply, only in a very general way could I apply the same rules to Delacroix [as] I would to Mondrian.

For myself, this kind of purity or intensity is just not possible. I require the complexity and confounding values that figuration, and one step further in this confounding—narrative—provokes or forces on me. I cannot rise to an extremity of pure color without losing my visible subject. And this would be the case if the surface became too insistent or confectionary. Surface, you see, is rather low in my book of rules unless it

represents the final expression of the form. Too much *surface agitato* makes me think of the man who is smiling only with his face. Hence, sacrifices become the order of my day, sacrifices of sheer painting magic. Too much of the latter obscures the idea, calls too much attention to itself.

But I don't want to underestimate the privileges a painter has today to become . . . aesthetic. Language, finally, is the key. Having invented or discovered or rediscovered a language with all the possible reference to the tradition behind one, with the awareness of the uses of language in the past as in culture, if you will—remember it's never just raw experience or chanciness (it has to be tested) though heaven knows it may come to that—one must learn how to be free and expressive. Which brings me to the factor among the hierarchies easily overlooked but which I believe is crucial to the final revelation: that of the pressure of personality, of decision, of awareness and delight in making, the signature, the final evidence of the body: it's the touch. Often dismissed condescendingly, as in, "oh, she has a nice touch," as if this factor were not comparable to great design or color. Yet the touch is one of the most endearing aspects of the maker, or maybe the most revealing. In fact, it may well be the magical way painting becomes drawing and drawing becomes painting.

Dear C.D.,

I was enchanted by your description of and delight in, your new French easel; the expeditiousness of it all you describe as if it were a new house with all the right corridors, shelves and closets for the creative life. In a way this piece of property will give you privileges (and responsibilities) you never dreamed of after umpteen years in the studio.

I think the painter who stumbles on to his Motif laden with flapping canvas, this paragon of a box, and all the extra gear he can't seem to do without, is pretty heroic. He's a sitting duck for insects, gapers, dogs, inquisitors, aficionados ("do you paint by trial and error, or do you have a plan?"), confessions ("my analyst suggested I paint—you know, my frustrations. . . . "). He's a victim of chills or burning heat, sudden squalls, sand, mud, poison ivy, dehydration, insects, photographers, self-ordained art critics, chummy kibitzers—everyone who has ventured forth has a tale to tell. My favorite is Louis Finkelstein's. After many attempts to get rid of a particularly pesky pest who asked him to paint him, Louis daubed him with cadmium red. Plus, and the biggest plus of all, the disconcerting, continuous involuntary response to multiple and ever-changing stimuli. In a very real sense it's flux.

When you confront the landscape you leave behind your privacy, your insulation, often what you deem as your right tempo, your inwardness, the daily reprieve of mistakes and corrections—in the studio your "forming" may be up to change but the vision or earned rule by which you work can be pretty intractable. Significantly, outside, you leave your will to control. You divest yourself of this supporting bulwark for certain responses to the kind of experience no mere pigment and

the best will in the world can approach. Before your defenses of style, rule, strategy, you are left a little helpless, productively helpless?. . .

Happily, the yield is not predictable else one could offer it in the same way we recommend vitamin therapy or a new suit. And it may serve you this way—as momentary relief, as a general freshening. On the other hand it could quite permanently change all your conceptions—well and honorably earned—for a passage, maybe, even a life-work—you cannot anticipate let alone charter. It could be a risky business after all.

Does this simply represent long passé traditional baggage? A fait accompli? Delacroix said, "The new is always the most ancient thing there is." Or to say it another way, Whatever is new for you is indeed new, and, very probably, true!

Dear E.O.,

Between 5:45 and 6:15 in the morning I go walking, and permit myself the reward of coffee and a buttered roll, or a boiled egg sometimes, in a pleasant coffee shop where privacy and intimacy are cheerily combined.

At this hour, the festooned private carting companies with their sanitized names menace the streets. The homeless are still sleeping under their cardboard boxes. An occasional gypsy is moving among the beer cans collecting for his cart made up of colored plastic bags and coat hangers. Often there is evidence of a calamity of the night: torn shoes, the scattered remnants of a pocketbook. . . . The Korean markets are open for business—yesterday's flowers are being cut back and re-spritzed for future sales. . . .

I rehearse my favorite daydream: to live on top of the tallest building. Several high, squat towers are ear-marked for this purpose.

You should not be diffident or apologetic for your good book. It's a truthful and valuable document, and important! I respect your hero worship, your faith in the literary life. You've submitted yourself to your material. You've held nothing back. And in so doing you've reclaimed M. N. from oblivion and set her in orbit as she deserves.

But it's no wonder that you feel lost to your own ego. It's a natural concomitant of making something with the urgent requirement of objectivity, with all the man-hours involved, the starts and stops, the faltering hopefulness and beginnings [they] always promise but rarely fulfill. So it is this which validates our commitment, though it may not protect us from the busy-work of erosion.

Yet, something does happen, at least for me, when I let myself fall into the work-in-progress. The mirrors begin to

recede. The exigencies of the recalcitrant material in which I labor begin to absorb me. I fall into illusion, into chimeras. I don't measure any longer my day to day progress, or take the temperature of my confidence. I become a somnambulist. The waters close over me and I am young again.

Plates

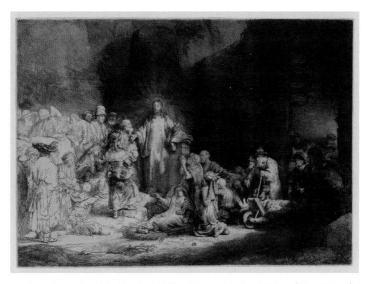

Rembrandt van Rijn, *The Hundred Guilder Print*, 1649. 11 x 15½ in. (28 x 39.3 cm). Etching, engraving, and drypoint; second state of two. © The Metropolitan Museum of Art.

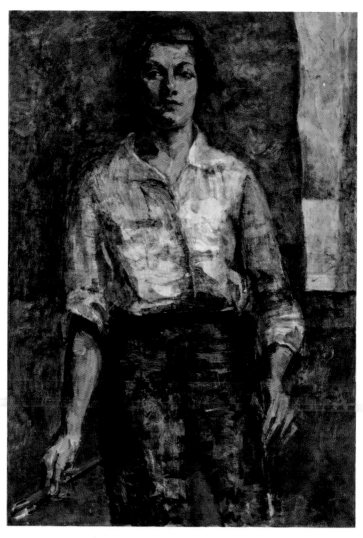

Rosemarie Beck, *Self-Portrait*, 1953, oil on canvas, 34 x 24 in. Courtesy of the Rosemarie Beck Foundation.

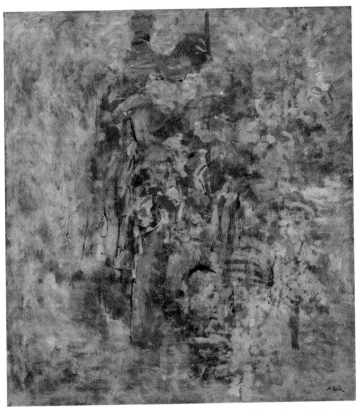

Rosemarie Beck (1923–2003), *Number 3, 1954*, 1953–54. Oil on linen, 50^{1}/$_{16}$ x 46 in. (127.2 x 116.8 cm). Whitney Museum of American Art, New York; purchase, with funds from the Living Arts Foundation Fund 55.51. © The Rosemarie Beck Foundation.

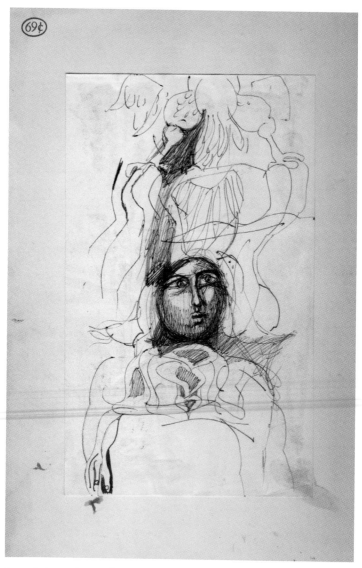

Journal #6 cover (interior). Courtesy of the Rosemarie Beck Foundation.

Question: Your present work has the air of a retreat or harking back to past solutions perhaps for rectification and growth?

Beck: The academy of the advance guard is no less precedent-bound than all the old academies and can bind (and blind) with its conventions as does any academy.
 I had no project 'to go back' but began simply to look at objects as directly as I could and found them inescapably intriguing. Heretofore I was concerned, among other things, with the use of light. I began to want to put my light on something.
Question : But isn't your picture plane and your material the only true something, which you have all avowed time and again, for the painter?
Beck: It always is. I needed a denser problem - there's no explaining this altogether except to say, a painter wants to use and be used by all sides of himself. I was not permitting enough of my range to be exercised. This retreat, then, does not represent for me at least, nostalgia for the Museums (i had that when I painted non objectively)) but an evolution I was not in conscious control of.
Question: Your paintings don't demonstrate brush stroke, brio, expressionism. Is this deliberate?
Beck: Yes, in so far as attack and flourish, temperament or whatever it s called would only obscure my idea.
Question: What is your idea?
Beck: It is not verbalizable, only in little part: tops and bottoms, edges, the entire surface - its pulsebeat, things behind things, and in front and inside things. I don't want to summerize objects or use them as motifs but discover the forms they possess which can approximate my feelings.
Question: I notice chronologically your pictures tend to become more and more realistic.
Beck: When you begin to discover something there is only one morality: to go all the way even if it takes you to the photo-graph. (which of course it never can). Realism, as opposed to naturalism. I believe my contemporaries are naturalists.
Question : How do you regard what they do in relation to your own work?
Beck: They are chiefly concerned with an in stantaneous whole . I am concerned as much with the parts and their separability in my whole. We are all concerned more with a fragment of reality than generality. Which is simply another way of sayin g we possess subjective-not world views.
Question: Had you any misgivings as an abstract painter?
Beck : Frequently. I this respect.if there is a natural telogy of d ~~~~ if one wishes to dramatize some of the paradoxes of painting recognizable object are necessary. They are necessary for all the contingencies outside of art ~~~~
~~~~ ~~~~ ~~~~ ~~~~
for this for me in any case

Rhetorical questionnaire created by Beck in January 1959 included in *Journal #4*.
Courtesy of the Rosemarie Beck Foundation.

Rosemarie Beck, *Portrait of Robert*, 1959. Oil on canvas. 36¼ x 46⅛ in (92 x 117.2 cm). Gift of Joseph Hirshhorn, 1966. Photography by Michael Stewart. Hirshhorn Museum and Sculpture Garden, Smithsonian Institution. © Rosemarie Beck Foundation.

Rosemarie Beck, *Le Maquillage II*, 1961–62, oil on linen, 54 x 76 in. Courtesy of the Rosemarie Beck Foundation.

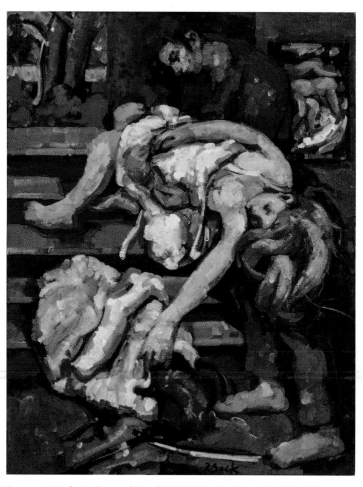

Rosemarie Beck, *Orpheus and Eurydice IV*, 1970, oil on linen, 38 x 30 in. Courtesy of the Rosemarie Beck Foundation.

# II.
# Other Writings

**E.N.:** *Beck returned to painting with the* Orpheus *series (1969–75) after a dark period following a near fatal car accident outside of Woodstock in 1973. She sustained a broken arm and lost her ability to play violin. With* Orpheus, *Beck embraced death, melancholy, and the loss of one's art as themes, as well as a way to come to the other side of trauma. After this period, and throughout the 1970s, Beck became more willing to discuss the overt sources of her work and their connection to her autobiography. The first text is exemplary in its biographical account: she discusses how she arrived at painting, the odd jobs she took in order to support herself, as well as the milieu in which she worked. The second essay, which I have titled "On the Orpheus Theme," is an extended excerpt from a series of lecture notes that appeared in the same folder as the former. Here, Beck discusses her motivations for turning to Orpheus as a subject.*

# "Lecture Delivered at Queens College" (1975)

Throughout my professional days I've avoided public confessionals, secrets of the life and of the studio. This is not modesty nor, strictly, diffidence. Say, rather that the catalyzing moments of my life lie too deep for explication—I don't understand them, don't want to. Archaically I held to the belief that you have to be hurt into poetry; and that you better not meddle with the source.

I was the "negative capabilities" kind of child. That is, not one who acts, or plays, or gets into mischief, but rather one who is acted upon, who prefers to watch, opts for being alone. Even when I was very young, my most precise satisfactions came from Making something, not from being somebody. I enjoyed telling horror stories. I invented a language which my sister

and cousin and several neighborhood children spoke for several summers.

During my first school years, I was silent, and hence thought backward.[23] But I redeemed myself one day by reciting the "Inchcape Rock" and thus discovered the wondrous efficacy of wearing a mask! At about ten or eleven I began to take violin lessons from a teacher of all instruments. How I envied the accordion, the saxophone and the banjo students, who made such accomplished sounds. On the other hand, I was given arrangements of melodies from famous operas, with the abbreviated, glamorous plots printed into the score. By the time I was twelve I was spiritedly mimicking my way through several violin concerti—without technique, of course—but again, safely secured behind the mask of a gypsy.

In high school, I painted sets for the theater department and to my delight, was given free reign among the glue pots and the canvas flats. I particularly remember a production of Thornton Wilder's *Our Town*. A drug store set was required which I painted—just shelves, bottles, shadows—entirely in grisaille. It was a turning point for me: the first time I was ever to make a painting in which I worked with specific limitations. Within the confines of a rule I felt as though I had invented the wheel (well, at least the button!). On the other hand, I innocently furnished an 18th century interior with two lambent Corots. Of course, no one noticed the incongruity. It seems unfortunate to me today that I had no guidance at this time. Still, a very happy avidity was born in me which is undiminished today and for which I can only feel grateful.

At Oberlin Conservatory, where I was dispatched to get the

---

23 Here, Beck is suggesting that she may have been dyslexic.

gypsy out of me and to be trained as a serious fiddler (my dear father had visions of me as the first violin in an orchestra, or simply to teach), I discovered very soon that my heart was not in the practice room. Instead, my instinct led me to the small but excellent art history department, the art museum, and its superb Carnegie-endowed library. And there I was fatally assaulted by "monuments of un-aging intellect" in the form of twelve-foot high slides on a silver screen.

Had I been shown that first morning a Byzantine icon, a Persian rug, or the Apollo Belvedere, my future might have taken a different course. But it was a detail from a Rembrandt etching and at 7:50 am, without breakfast.[24] It was a case of First Love, and I was traumatized forever. I transferred from the Conservatory to the art department, and there followed several impacted years.

All the same, I emerged equipped for nothing. In New York, I tinted photographs, I worked for George Amberg of the Dance Department of MoMA, I went to Columbia and the Institute of Fine Arts (NYU) for further study with Erwin (*sic*) Panofsky, who wanted me to do my thesis on "Archaisms in late 15th Century Flemish Painting." I even enrolled at the Art Student's League—briefly, 2½ weeks—but when the instructor asked me why I had put a dab of purple on the model's loincloth, I left.

Presently, I became Kurt Seligmann's assistant and gopher. In this capacity my most distinguished errand was the delivery of a package to Andre Breton. Monsieur Breton received me in a book-lined room among coffee cups, brandy glasses, and general disarray, plus the presence of a near-totally nude lady with shoes on. Seligmann's teaching consisted of wondrous

---

24  Rembrandt, *The Hundred Guilder Print* (1649). See p. 57.

arcane remarks such as: "In art, two plus two equals five minus one." I wanted to impress him with my awareness but I got nowhere. He called me The Carpenter. I distrusted fantasy (I still do) and the creepy vision of the Surrealists—Tcheliwiev (sic), ballet sets, Dali, all being repugnant to me, and alas, my teacher's art as well. I think Seligmann was testing my loyalty when he asked me to deliver a painting to his gallery. The following autumn, I married Robert Phelps. We had a thousand dollars, all of the late string quartets of Beethoven, and a summer cottage for the winter. Time to learn how to be an artist. I started with Giotto. In the spring, mercifully, we moved to Woodstock, NY, where Philip Guston had recently settled, and where Raoul Hague and Bradley Tomlin were already sometime residents. Thereafter my education was not so lonely. I had masters to listen to, to interrupt, to watch. I could learn by example as well as precept.

## Three Anecdotes

Kierkegaard was much with us in those days (the late 40s), and "teleological inevitability," tended to be the burden of our midnight talks. Was abstract art inevitable, necessary, historically unavoidable?

Among those who KNEW, the NEW, the avant garde, was the only courageous position for the young artist. But I had not yet finished my self-imposed education. I had leapt from Giotto and Durer past the entire 16th, 17th and 18th centuries to Cezanne and Cubism. And yet, I was convinced that all art is essentially one creature, and one's learning begins at the periphery of one's own time.

We spent the winter of 1949–50 in Manhattan. Robert had begun the Grove Press and we were living on Grove Street in

Greenwich Village. In fact, I was stashed away in Westchester County much of the time with a newborn child and no place to work. Bradley Tomlin was sharing a 4th Avenue loft with Robert Motherwell, which they opened once or twice a week as a school to pay the rent; to my plight, they snuck me in. I remember [Tomlin] saying, "Paint well Becki, for god's sake!"

Once a week Motherwell appeared late in the evening and talked. He talked about his own tastes, his rewarding, his personal life, his cooking—all brilliantly. But rarely analyzed, criticized, defined, described or offered suggestions as to anyone else's work. At most, he would say something like this: "You were right to put that white in the painting. I knew it needed it—right there." I found this enlightening, confirming, and extraordinarily liberating though I could not have told you why. Perhaps it was simply having someone else's eye on my work, being in a way, disburdened.

I had three exhibitions in New York as an abstract painter: 1953, 1955, and 1956. When I was hired to teach at Vassar, it was as an "abstract painter," to teach "abstract painting." But I was able to do this only by establishing a premise—that is, by using apples or a model as a referent. And since painting was not important in the Vassar curriculum—a brief quickening once a week, hands in the dye and all that—I was given carte blanche. Models were allowed. And lucky for me, since by this time I had become a "closet" realist.

1956–58 represented a crisis for me. The ore in my abstract vein had thinned. My theme or imagery—for abstract painting does have imagery—had atomized and was in danger of atomizing altogether. All that was left to me, it seemed, was a kind of writing. Many years later, Clinton Hill said that this alleged end was in fact a beginning, and scolded me for not recognizing

this at the time. [25] In any case, I believed I needed refreshment from the visible world of forms, and a less self-conscious attitude about my position as an abstract painter. Hence—slowly, painfully, gropingly—I returned to figurative imagery. Temporarily, I hoped. But the paradox of the REAL versus the ABSTRACT took hold, crescendoed, swelled and engulfed me, like a tidal wave.

Eventually my themes began to come from the outside, as in genre or narrative painting of the past. And I began to understand that you learn from any position, and not necessarily by any abstract imperative, inevitable steps, teleological necessities, etc.—and least of all, from any trends, movements or coteries. You learn from your own temperament. You learn from what you loved at your beginning (in my case, that Rembrandt etching). You learn, above all, by trusting your innermost orders, and by consenting to your deepest aloneness.

---

25 Here Beck suggests that her work was beginning to become more reductive. The painter Clinton Hill (1922–2003) was inferring that her work had begun to suggest Color Field painting. Beck noted in the margin of this text: "If I had, would I have entered history?"

## "On the Orpheus Theme" (1975)

I resist revealing myself. I never confess. I'm comfortable with secrets. Regarding my recent work, I don't think I'd be consternated if the narrative point were missed. I hope the painting itself is strong enough for this not to matter. However, now that I am finished with this particular theme—theme rather than story—it no longer matters to me whether I allow the thoughts and intuitions which have eddied in and about my last few years to rest in a few statements.

Almost every aspect of the Orpheus legend revealed or parceled some interior or exterior event of my own life. And so, in a way, I believe I didn't choose the subject so much as it chose me.

Essentially the myth is about VOCATION, the dedicated life. Orpheus is a gifted creature whose talent is so sovereign,

innocent, direct, the beasts, even the rocks, are persuaded by his voice. He is given Eurydice, his muse, his inspiration, with which to celebrate this joyfulness and disguise his essential loneliness. But she is destroyed—perhaps Orpheus became too complicated, or too self-conscious, or wanted too much? Too much system, perhaps, and not enough trust?

Orpheus, hurt and disillusioned—alone—sets off to recover her. He must go very far—or rather, very deep—into his deepest despair. By the very eloquence of his needfulness, he is finally able to persuade the powers of the underworld to return Eurydice to him on the condition that he not look back—that is, not succumb to any of the devils of self-questioning, doubt, distrust, or fear that say primitive vitality. But Orpheus cannot resist testing and proving, and Eurydice is taken from him for the last time. Ultimately he is destroyed—by madness, by the way things are, by the world, REALITY.

A very free, a very arbitrary interpretation. However, when I consider a narrative subject, this is how I think in one sense.

On another, less translatable level, I get a rhythm or combination of shapes that need to be embodied in some figuration that is not merely a piece of nature: a nude or a still life, which corresponds to the analogic or metaphoric processes by which I live from day to day in my better moments.

And on another level still, on the side of ambition or aspiration or whatever you wish to call it, having a theme—and with it certain limitations—keeps the imagination and invention in rigorous training.

> "All, all of a piece throughout,
> Thy chase had a beast in view."
>
> —John Dryden

Is this solipsism? Narcissism masquerading as myth? I am accused of not being a narrative painter—at best, just a painter. Still I seem to need this extra-painting compliment to keep the wings of my albatross from dragging and flagging. And this makes me think of the possible sources of inspiration:

> Boredom
> Sublimation
> In love with the subject
> In love-generally
> In love with form, an ideal form
> Sheer mental energy
> Spirit of invention
> Nostalgia for the masterpiece
> Nostalgia for the past, one's own past—
>     lost youth, happiness, innocence.
> The spirit of dissatisfaction
> gratitude and the wish to praise
> In love with the ephemeral, with facts, with
>     nature *per se.*
> Knowing, but not knowing you know.
> The wish to instruct.

**E.N.:** *Beck had a series of exhibitions in 1980 and this talk was delivered at Cornell University on the occasion of her exhibition there. By the time she wrote this lecture, Beck had used* Orpheus, The Tempest *and* The Metamorphosis *as themes, and she was just beginning to embark on series based on Atalanta and Apollo and Daphne. This talk is a synthesis of the ideas and conceptual underpinnings that were involved in Beck's use of narrative subjects. Throughout her writing, Beck addressed the relationship between narrative content and the visual elements of painting— namely—that that the formal elements inherent to painting often have to "fight" with the internal logic and structure inherent to literature. This tussle between "symbol and fact" and the "insolubles" that arise from this friction are the animus in Beck's work.*

## "The Meaning of Persona in Narrative Painting" (1980)

I'm reluctant to get at this statement; I keep balking and procrastinating. Apart from constitutional inertia, the reason seems to lie in the nature of the subject. As the subject lies in the place where we cannot perceive it, let alone predict our effects. To put it more simply: we paint it because we cannot say it any other way. The language of words often fails us, yet as narrative painters we want some of the same privileges accorded writers. We want to be as witness-bearing or specific as any letter writer, who can say, for example: "It rains, it's late and cold and I am in despair." We want to concretize and specify the emotion. In other words "Art is not enough!" or art is not solely for the eye.

Given the postulations of the last 150 years or so, that formal relations—art for its own sake—represents the mother

lode of painting, its single importunate concern, one might wonder how and to what degree the narrative modifies or qualifies this position. Or, in the light of the extraordinary means available—cinema, giant screens, billboard, television, computer imaging—does narrative painting have any raison d'être? Especially since the narrative aspect has always seemed the slightly muddying component of painting anyway, weighing it down, qualifying its pure pleasure with extra meanings. Besides, personal experience tells me it's the very aspect of painting nobody wants to talk about except for the village idiot for whom it is the only aspect.

The degree to which painterly indulgences, virtuosities, richness in the process, take over, puts the narrative at risk to tell itself. In the modern sensibility the formal elements have a way of overwhelming or sinking the narrative. The narrative aspect needs for its survival sacrifice, synthesizing, else equilibrium is lost. And I'd sink fast if I accept the assumption that everything the painter commits is narrative, though of course, in a way it is. If this is a truth however, it nonetheless offends me. The word *persona* enlarges our discussion in a way that could easily become capricious. Every painterly moment is potentially personifiable. That dab of cadmium yellow, "C'est moi!" Well, this is how I'm thinking before I am thinking.

Insofar as splendid, effective large-scale alternatives have taken over the previous task of narrative painting, the history of modern art asserts the unfeasibility of this position, what possible justification have we for using it now? Fundamentally I believe it is simply temperament. Ambition may be one of the components—to paint like the masters, to track the unknown, and to relish, in some trepidation, being off-center, a little

vulgar, anachronistic. An equation is set up immediately when talking of narrative painting: formal relations are to story what story is to expression. Layers of complexity proliferate, and questions breed storms of alternatives. . . . For example, how to accomplish the whole's swiftness with the part's requirement for a slower tempo in the reading? What of the arbitrary, stylized or otherwise transformed appearance of things against their alleged "real" appearance? The time of the picture against the real time of day, as witness to, say, the position of the light? The endless contradictions of the *how* and *what* assail, and the power of meanings beginning, thus, to germinate could keep you up at night.

This is the age of the diary, the tell-all talk show, the autobiography, of wanting to get in the act in any way possible. Defense of this need, finally it's all we have to give, this self and this experience of selfness in its guises and disguises as it addresses language and as it confers secrets and meanings. I am thinking here of the late Philip Guston and Leland Bell.

Leland was resistant to questions about his meaning. I remember a panel over twenty years ago on this very subject in which I suggested a possible interpretation: "loss of innocence"—something like that. Total rejecting silence flashed from him. Philip on the other hand welcomed discussion. "You see that guy over there?"—this when his work was still patently abstract—"he's hitting this other guy." Guston enjoyed putting salt on his own tail as well as the tale. Not being naturalistic was what they had in common. In differing ways they forged the figuration appropriate to their allegories while liberating a language for the purpose. Each was a passionate hero worshiper and harvester in the history of art.

Guston used cartoon-like images, iconography drawn from

his earliest adolescent work. Very reduced, boldly, almost perversely reduced, to the aspects of the figure that would most keenly tell his story. Many bent legs, on floor boards became a crowd in a cellar; stone books, a pointing hand, light bulb, paint brushes, easel, etc., became figuration enough for unwavering narrative fertility. Thingness, objectness, characterized this work. Yet he never sacrificed painterliness hence he is never merely illustrative or theoretical but poignant and formal and universal. He wanted to make a memorable image with which to warn, to instruct and charm. He was the only artist I have ever known who could, on occasion, laugh with pleasure at his own work.

Leland Bell's subject is intimist. It consists of several family groups. The scene, the basic composition, a tableau, changes little in the course of a long life's work, only in variations in its handling. The paintings are classical in scale, intimist in subject, reductive in handling, epiphanic in meaning. Where Guston invented iconic shapes or objects to move about freely, uninhibitedly on the chessboard of his imagination, Bell used arabesque, rhythm, flat, saturated very original color and an implacable thread around the form and sometimes through the form. Each was mad about art and this passion was secreted almost as a persona. Each used himself unabashedly as the chief protagonist.

[In] everything they touched their voices are clear and unmistakable. With more intuition than logic I'm going to say: it's only this quality that creates the persona—this having so certainly a voice. The rest is theory and surmise. This quality, detached from virtuosity, or high-mindedness, or culture, or good intentions (which qualities the art may indeed embody) is awfully hard to define, yet is always recognizable.

I'm afraid I am going to close these paragraphs with a pat statement: the persona is what remains to a work of art when all comment is finally silent. It is evidence of the self-fulfilling artist inhabiting his right forms.

**E.N.:** *In 1999, a retrospective of Beck's work was on view at Queens College, Smith College, and Swarthmore College, and with it came a series of speaking engagements. Beck used this lecture format as a way to create a direct and personal link between her audience and herself, structuring the lecture as a walk through various galleries of the Metropolitan Museum of Art to view a selection of works that were formative in her own development. The reflections gathered in this lecture represent Beck's most direct ekphrastic writing and give one a sense of the formal elements that she valued. In a teaching statement written twenty years prior, Beck wrote: "My students serve as my private laboratory for testing my predilections, biases, presumptions. I found myself unable to teach anything about the interior orders of painting without an external referent, just as, it seemed to me then, no single student was able to understand the meaning of painting—that is to say, abstraction—without the 'image.'" The following text is a synthesis of the pedagogic/artistic/literary values Beck sought to impart to both students and her public.*

## "Reflections on Works from the Metropolitan Museum of Art" (1999)

Before paintings I become mute, or worse, stupid. However, when casting about for a theme for this day's talk, I finally decided to fabricate out of my looking at, and drawing from, certain paintings in the Metropolitan Museum collection: paintings I love and admire though they may not be the *chef d'oeuvre's* their masters conceived. And to limit my discussion to portraits or figures, further to that aspect within the formal vocabulary we call the triangle or pyramid—the three-dimensional triangle. If there is arcanery regarding the triangle, I don't know anything about it. The miracle, the capacious miracle, of the rectangle as the container of formal reality is enough arcanery for me. However, I believe the triangle is more functional, more flexible, and adaptable than the H, the

box, the circle or the arabesque. Nothing I'm going to say is cast in stone. Call it ruminating in an unstructured way, letting thoughts eddy where they will.

## Rembrandt, *Self Portrait* (1660)

No matter what blockbuster show is mounted at the Met, I go directly to the Rembrandt self-portrait. I guess I need to assure myself that it is there. It's my lodestar: my north, south, east and west nodes. It focuses me. Everything else I look at and consider is in relation to it. Approached from a distance down long corridors it seems large and enlarging—it is in fact a bit larger than the conventional portrait scale and why not? Very real, magnetic. Perhaps not as assumptive or arrogating as the great Frick portrait but I prefer it. Clearly it was painted for the private eye in 1660; no wish to please, or parade technical felicities. He still wears gorgeous trappings and prideful accoutrements in the Frick portrait. It's all gone here, or, the stuff is only worn to keep him warm, indifferently.

It's a big thick pyramid veering slightly into space on its left, the thickness of the modeling, the depth and distances from part to part make the painting expand, literally breathe. The Frick portrait is more compressed.

Every touch, every stroke, proclaims itself a modern painting. That is to say a conscious affirmation of its painted-ness, and by extension, of the picture plane. Very corporeal and only incidentally illusionistic, the highest points in the modeling are the forehead, nose, shoulders. Everything is there, everything is accountable whether visible or not—yet—no a priori schema exists for its stylistic reality, its intense plasticity.

No color, only earth tints and an implacable black in the beret made of more than black and so vital to the complexity of

the painting. One could write a book about Rembrandt's head pieces, a veritable autobiography, and perhaps someone has? From the elaborate feathered confections of his youth to the final turbans and dirty towels and the abbreviated rag of the Kenwood portrait. Artists' secrets are almost always revealed in the work. As for this beret, I'd happily give a student an A if he could draw it with all that it implies in its subtlety, its implication of space.

You cannot draw this portrait with lines. Resolution by anything so comforting as this contour is unthinkable. Maybe this explains why people don't stop long before it but move on to more legible paintings? Yet nothing is remote in the language. It is totally accountable with no wildness or expressionism or showiness or flourish.

So what holds me, what makes me tearful and expectant and, impiously wanting to hold a brush to it believing I am painting it? Perhaps because it hovers so commandingly, unabashedly, between nature and art. We know everything except the mystery of its performance—when in the process did he do what? Before anything was there what was there? One answer, of course: 40 years of being Rembrandt.

### Rembrandt, *Hendrickje Storels* (1660)

This little portrait was painted in 1660 at the same time as the self-portrait and moves me, if possible, even more. She was only 35 and was to die of plague several years later. But she's already old. Still as beautiful as she [was] when she appeared as the woman lifting her skirt in the London painting. Here: used, worn.

It's a testament to the balance between the general and the particular, to the unending series of interpenetrating relations that create this equation. This quality of relationship-ness is, in

my opinion, far more subtle and complex than an infinite, no doubt honorable, particularization for it depends on the constant interplay and qualification of the part to the whole and is non-descriptive. It's always about abstraction, always about painting and hence, profoundly confessional.

It is academic of me to apply the rule of the triangle to this gorgeous piece of poetic truth, but the triangle is there. What interests me is the distance Rembrandt has come from the skilled performance-minded upholsterer of his early narratives to the metamorphosis. Astonishing how the late works of great masters have everything in common and look remarkably like a Titian, Degas, Cezanne.

The erased, generalized hand is wonderfully there—undeceptively, un-schematically, the round or illusionistic lives comfortably with the flat or planar.

### Corot, *Sibylle* (1870)

Corot is the great-grand nephew of Rembrandt. He may be a French 19th Century student of Ingres and inheritor of an elaborate classical tradition of refinements yet I think that his feeling for form is closer to the 17th century Dutch master than to his contemporaries, certainly in his figure painting, in the way he develops form from the general to the particular and back again, and in the way the surface plane is stressed, in the feeling of compression, and then too in the stuff itself: the paint as paint or tinted earth becoming flesh. There are edges, overlaps, but no shapely contours to latch onto.

The painting is essentially a massive pyramid slightly skewed by the strong turning of neck and head.

Corot belongs to the very small band of the silver painters (Vermeer, Philip Guston and Velasquez are among the others).

The palette is weighty with tone and often meaty in application, yet cool—all color is touched with grey including the flesh. It is difficult to name the color, we know it only by relations. The values are close or strikingly black and white, the result by some alembic is light. A kind of detachment or remove . . . from theory, argument, sweat or involvement with the sitter. The painting is intensely worked all by way of differing degrees of finish: you feel often he needed to generalize or return to an earlier stage in the development of the composition. He does not move from A to B, but rather from A to Z. The brush is weighty, palpable. The metaphor, as in Rembrandt, resides in bridging the impossible gulf between language and flesh. I am reminded also of Titian's last work in Venice, *The Pieta*. The secret is in the tempo, a mystery, fast or slow? By what sequence? How can it be so real and so removed, so mysterious and haunting? How sonorous like the sound of a cello.

**Bronzino, *Portrait of a Young Man* (1530s)**
Strong central triangle, and though the figure is turned to the right, every element in the composition is designed to bring us to the surface plane including the slightly uncomfortable right hand holding a book.

It is clear as a pane of glass. The effect is wonderfully harmonious. There is no real color except black, grayed purple, a touch of ochre, dun grays, lavender grays, etc. Among the hierarchies in painting and drawing shape is paramount here. The paintings by Del Sarto and others to the right and left of this Bronzino pale in comparison; they look undecided and fussy. Austerity, pride as a painting, and confidence parallel precisely the arrogant patrician young man's sense of self all without hesitation or anxiety. The painting never fumbles. I noticed the entrance of

every moulding, every panel, every decorative bit, pendentive, chair-part, as blade-like in its formal effect. And in these formalities a psychological component is strongly effected.

### Veronese, *Boy with Greyhound* (1570s)

Through the door I glimpse the Veronese full standing figure which compares with the Bronzino in that it is composed of the same dun colors—gray greens and off whites yet remarkably different in effect. Its mode is more natural—realistic (?)—for one thing. The boy is fleshy and present. You cannot think of the abstraction first, but of a young man not so much posing or arranged as vulnerably caught. The boy and his dog are tenderly, a bit uncertainly, together while the details and surface activity are rather solid, sculptural, which only enhances the precariousness of life versus art. The more I look the better the painting seems to be.

### Velasquez, *Count Olivares on Horseback* (1635)

Technically it is the most felicitous painting in the Met for its sheer virtuosity, painterly richness, tonal harmony (pure silver) and for the perfect balance of detail and conception, it has no equal. When I compare it to the great portrait of his friend/servant which hangs next to it, which he obviously painted for himself—personal, intimate, real—I see how fictional and abstract the equestrian is. It depends upon a priori strategies, a precedent which makes me believe in the productive energy one gets from a commission. Like the good courier Velasquez was, he submitted without condescension to his assignment with perfect professionality. It flies, it gleams. The fluent diagonal only underscores the painting's extraordinary equilibrium. Entirely calculated, worlds exist between the horse's hooves!

When sketching from this painting I am never certain what is most important among the hierarchies. Is it the performance virtuosity? The sense of its having been so surely rehearsed, calculated? It soars without a net. No sweat, no apparent struggle, hesitation, change of heart, to cast an all too human shadow. Parts to the whole—perfect. No forms really end, no form is quietly alone but echoing here and there in clouds, trees, smoke. Light against dark, dark against light. Still all of the machinations whisper that this is essentially a chiaroscuro painting. It gives me appetite and fills me with despair.

### Van Dyck, *Head of a Woman* (1618–20)

It's a triangle. Very modern yet I am strongly reminded of the 15th and 16th centuries. More modern in tone than Courbet's *Irish Woman* painted two centuries later.[26] The young woman with her long silvery neck is dressed in what look like men's clothing. Her long red hair is splayed out around her. Her head appears to have turned suddenly to her left. How different it is from the sunny extrovert *Venus and Adonis* of Reubens in the next room. How secret, individualized, hermetic, neurasthenic; she is truly known, however, by her creator. Which tempts me to speculate out of the world of aesthetics. But I'll let it be; it's enough to dream.

### Renoir, *Madame Charpentier and Her Children* (1871)

The painting is comprised of two commodious intersecting pyramids constantly threatened, happily, by delights of the physical world. It all appears to be a pretty unconflicted, bourgeois, hedonistic earthly paradise of flesh, surfaces, textures,

---

26 Gustave Courbet, *Jo, La Belle Irlandaise* (1865–66).

fur embroidery, lace, hair, lattice, rugs, flowers, fruits, objects, etc. And only a madly gifted painter could so bountifully and unselfconsciously bring it off. Only a powerful draftsman certain of his powers and fearless (or un-conflicted) before his feelings could lavish so much attention on such a variety of stuff without loss to the whole. It is a confection! Is there a dissonant note? Perhaps the floor which asserts a pertinent geometry to the whole against the constant melting-ness and efflorescence. So much virtuosity, limpidity, indulgence. A perfect balance of movement and stillness, of transparencies and opacity. The walls quiver, the fur is thick, the hair glossy.

A way of life is celebrated. Unqualified. No looking into cups for spiders, no irony, no melancholy attitude. Sheer celebration!

My mind wanders into this way of life, into other rooms where servants are pounding pillows and building chocolate confections. Only Colette would produce such a dossier of physical sensations without attendant indigestion!

It was not long after this performance that Renoir suffered a crisis of faith: "I no longer know how to paint and draw," he said.

### Cezanne, *Madame Cezanne in Red* (1888–90)

It is confrontational. Nothing is hidden or slurred in this mighty pyramidal painting. No summary glissando moments, no comforting illusionism (I believe turned upside down it would yield the same formal satisfactions.). No upholstery, flourishes, beguilements of the specific. It is composed of an unrelenting substance: The Exfoliating of Planes. This substance is in a way the metaphor. Well, it fatally altered the art that was to follow as inexorably as Bach's well-tempered keyboard did for succeeding generations of composers. Not to

acknowledge this would have to represent a failure of culture or consciousness.

This portrait has a formidable presence. The figure tilts but does not fall. We are always moving toward the head. It is monumental and classical but does not depend upon classical solutions. Like counter-point in music, there are ongoing echoing analogies.

The existential stance seems clearer to me here than, say, in *The Card Players*. He was on a voyage to some place he could not know, hence every formal moment, every *petit sensation* is dependent upon every other and structurally crucial.

I wonder if he knew how virtually important he was to us, is to us; or, like Galahad, who after having returned from the long quest for the grail asks the Knights of the Round Table to describe it for him since he cannot see it for himself?

Suddenly I am athwart [with] the emotions I had visiting the large show of his work in Philadelphia several years ago.[27] Before this trajectory of commitment I wanted to do my life work over again!

---

27 The *Cézanne* exhibition was on view at the Philadelphia Museum of Art from May 30–September 1, 1996.

# Acknowledgments

Painter Martha Hayden, the primary caretaker of Rosemarie Beck's archive, has tirelessly stewarded and catalogued Beck's work as both a labor of love and an imperative service to all future Beck scholars. I am grateful for the countless hours I have spent discussing Beck, looking at her work, and exchanging ideas with Martha during our many visits over the years. In addition, Doria Hughes has been extremely generous with her time and attention to this project. Her dedication to transcribing and archiving Beck's journals has proven critical to this work, as well as to future Beck studies. I would also like to thank Catherine Drabkin, Roger Phelps, and Colleen Randall, board members of the Rosemarie Beck Foundation, for their encouragement and trust. Kim Levin and Jennifer

Samet—both critics and art historians—have provided me with research materials, including their own interviews with Beck, which have served as a basis for much of this project. Martica Sawin's writings and research, as well as my interview with her, have further enriched this book.

My serious research on Beck began in 2013, as I was writing my master's thesis in the Art Writing Program at the School of Visual Arts. During that time, my thesis advisor, Ann Lauterbach, expanded my thinking about Beck. Additionally, Nancy Princenthal, Jennifer Krasinski, and David Levi-Strauss each encouraged me to pursue Beck as a subject, and have equally remained great sources of inspiration. Beck's commitment to teaching is reflected in the interviews I have conducted with her former students and colleagues. I would like to thank Dov Talpaz, Glenn Goldberg, Rackstraw Downes, Paul Resika, Diana Korzenik, Ro Lohin, Tyler Loftis, Doris Aach, Becky Yazdan, and Jason Eisner for their insight. Sabrina Mandanici, Jessica Holmes, Stephen Truax, and Andrew Zoppa have all been supportive and generous with their time and attention. Video recordings of Beck lecturing are housed at the New York Studio School, and I would like to thank the staff for making those available to me. Additionally, the staffs at the Frances Mulhall Achilles Library at the Whitney Museum of American Art, as well as at the Archives of American Art at the Smithsonian Institution, have been especially helpful in my research. The Hirschhorn Museum and the Whitney Museum of American Art additionally provided images for this project.

This book would not have been possible without the vision and support of Julia Klein of Soberscove Press, whose ongoing commitment to publishing artist's writings is invaluable. I

would also like to thank Kristi McGuire and Rita Lascaro for their rigorous work during the editing and design process.

I would finally like to thank my family for their limitless support.

Eric Sutphin